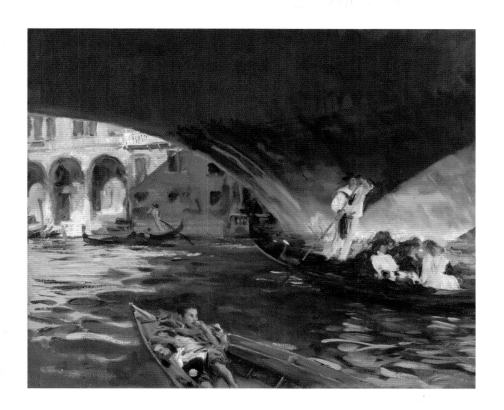

VMFA

VIRGINIA MUSEUM OF FINE ARTS

Contents

4 Welcome

6 Virginia Museum of Fine Arts

12 Modern and Contemporary

19 American

28 European

37 Decorative Arts 1890 to the Present

46 African

52 Pre-Columbian and Native American

58 Ancient Mediterranean

64 East Asian

70 South Asian

76 Photography

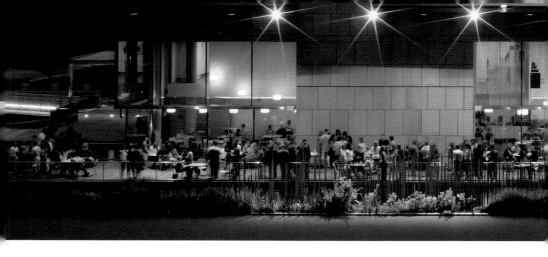

Welcome

In May 2010, when the Virginia Museum of Fine Arts opened the new James W. and Frances G. McGlothlin Wing, the whole community came out to celebrate. Today, the celebration continues as more visitors come to VMFA each year to view our world-class collection of art.

While the museum dates back to 1936, our collection has grown significantly during the last few years through acquisitions in all areas of our holdings. You can view these works in our galleries 365 days a year for free, making VMFA one of the most accessible museums in the country.

We are proud of our wide range of exhibitions that feature spectacular works of art by renowned masters such as Picasso and Rodin, as well as popular contemporary artists such as Dale Chihuly and Kehinde Wiley. These special shows focus on a varied array of cultures offering artifacts from different parts of the globe for all to see right here in Central Virginia. Talks by noted artists and

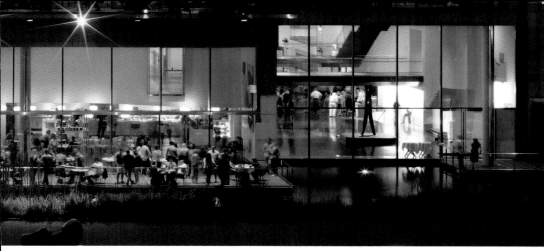

scholars provide rich context to works in our galleries. Diverse cultural events afford provocative and entertaining programming to visitors of all ages. Our beautiful E. Claiborne and Lora Robins Sculpture Garden is an urban oasis where visitors can contemplate sculptures, gather with friends, or even practice yoga.

As a state-supported institution, our mandate is "to enrich the lives of all Virginians" through art. Each day, we hope to do the same for those who come to enjoy all the treasures VMFA has to offer.

Alex Nyerges
Director

Virginia Museum of Fine Arts

Standing in the light-filled Cochrane Atrium of VMFA's McGlothlin Wing, visitors can enjoy the cutting-edge features of the museum's most recent addition and still feel connected to the institution's past. Open pedestrian bridges and elevators provide clear pathways among VMFA's diverse collections. Three-story glass walls on the east and west offer stunning views of Richmond's Boulevard and the Robins Sculpture Garden and reveal works on display, encouraging those outside to venture in.

Since opening in 2010, the James W. and Frances G. McGlothlin Wing has not only provided more space to display the museum's stunning collection, but

James W. and Frances G. McGlothlin Wing

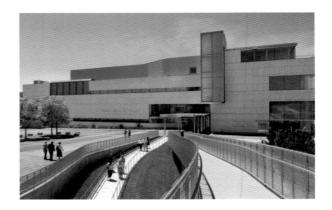

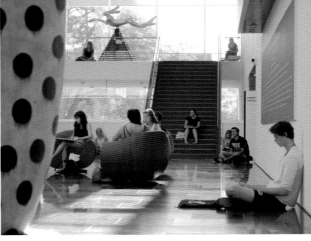

it has also helped transform the museum into a dynamic urban center. Blockbuster exhibitions that feature works by artists ranging from Pablo Picasso to Kehinde Wiley, and subjects as diverse as ancient Egyptian mummies and Hollywood costumes, have attracted hundreds of thousands of people from around the globe.

Visitors to the museum also enjoy fine dining in Amuse restaurant and more casual fare in the Best Café. Throughout its grounds and galleries, VMFA offers a welcoming and innovative space to explore, reflect, relax, and connect.

A Partnership and a Promise

When the Virginia Museum of Fine Arts first opened in 1936, its Georgian exterior barely hinted at the mandate given to the fledgling institution: to serve as the state's flagship art museum and as the headquarters for an educational network that would bring the best of world art to every corner of the Commonwealth.

The idea of a state-operated art museum in Richmond originally surfaced in 1919 when Judge John Barton Payne donated his collection of art

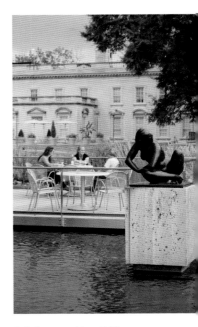

E. Claiborne and Lora Robins
Sculpture Garden

to Virginia. Gifts from other donors soon followed, and in 1932 Judge Payne proposed a challenge grant to build a museum for this burgeoning public art collection.

That challenge was accepted by Governor John Garland Pollard, who not only helped to raise private funds but also promoted the use of state revenues for operating expenses. The General Assembly approved legislation authorizing the museum in 1934 and, with additional funding from the Federal Work Projects Administration, Judge Payne's dream became a reality.

A Collection of Collections

More than eighty years later, VMFA has grown from a regional museum to a world-class cultural institution with a permanent collection of more than 33,000 objects that represent an array of global cultures and over 5,000 years of history. Every work of art belongs to the citizens of Virginia and is held in trust by the museum. While the state continues to provide essential support for operating costs, the growth of the collections has been financed through private gifts from patrons. It has been said that VMFA is a collection of collections, formed through the vision of passionate donors who have shared their holdings with the museum and, by extension, the people of Virginia.

One of VMFA's most celebrated collections is based on Lillian Thomas Pratt's 1947 bequest of jeweled objects by Carl Fabergé. Her gift, which included five imperial Easter eggs, elevated VMFA to the largest public collection of Fabergé outside Russia. That same year T. Catesby Jones donated his collection

of modern art with works by major twentieth-century artists including Pablo Picasso and Henri Matisse. Bequests from Adolph D. and Wilkins C. Williams and from Arthur and Margaret Glasgow significantly augmented the museum's holdings of European art in the early 1950s. The Glasgows' legacy was fully realized in 2011 when the museum received a transformational gift that catapulted VMFA's art acquisition funds to among those of the top five art museums in the nation. Paul Mellon, one of the museum's founding trustees, along with his wife, continued to enrich VMFA's European and American galleries with gifts of major examples of Impressionist, Post-Impressionist, and sporting art.

Beginning with their donation of three prints by Andy Warhol in 1969, Richmonders Sydney and Frances Lewis became instrumental in developing VMFA's collection of modern and contemporary art. They also expanded the museum's holdings of Art Nouveau and Art Deco, making it a collection that

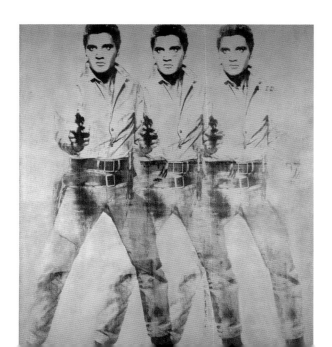

Andy Warhol, *Triple Elvis*, 1963

is now unrivaled outside Paris. Since 1988, patrons J. Harwood and Louise Cochrane established a generous endowment to acquire major examples of American art, while Jerome and Rita Gans gave VMFA a spectacular collection of eighteenth- and nineteenth-century English silver. The Ludwig and Rosy Fisher Collection of German Expressionist art—one of the last collections to leave Nazi-controlled Germany—was given to the museum as a gift-purchase in 2009.

In recent years, Pamela and Bill Royall have continued the tradition of enlightened collectors with donations that have expanded the collection, most significantly with works of twenty-first-century art.

With James and Frances McGlothlin's recent extraordinary gift of American art from the late nineteenth and early twentieth centuries, as well

as the addition of Frank Raysor's collection of some 10,000 prints, the museum's art collection continues to evolve.

Expansions

Today the VMFA campus incorporates several architectural styles that reflect the diverse range of art inside the museum. The original 1936 limestone and red brick building was designed by the Norfolk firm of Peebles and Ferguson. Its Georgian style has come to define European and American fine arts museums built during the late 1800s and early 1900s. Early additions to the north in 1954 and 1955 and to the south in 1970 used limestone and brick to echo the design of the original building. In 1985, patrons Sydney and Frances Lewis and Paul Mellon, together with the Commonwealth, provided funds for an addition known as the West Wing.

The museum's most recent expansion—designed by the architect Rick Mather—added more than 165,000 square feet to the existing footprint and visually unified the campus. The McGlothlin Wing provides space for special exhibitions, the Cochrane Atrium, the Margaret R. and Robert M. Freeman Library, the VMFA Shop, Best Café, Amuse Restaurant, the Art Education Center, and the David and Susan Goode Conservation Studios. Outside, more works from the VMFA collection are on view in the E. Claiborne and Lora Robins Sculpture Garden, which also offers three and a half acres of trails and shade trees, as well as places to sit and enjoy Virginia's great cultural treasure.

Modern and Contemporary

Iconic works by Jackson Pollock, Mark Rothko, Willem de Kooning, Helen Frankenthaler, Jasper Johns, Andy Warhol, and Anselm Kiefer are some of the highlights among VMFA's holdings of mid to late twentieth-century art. Sydney and Frances Lewis's gift of some 250 works provides the collection's core strength: American painting and sculpture from the 1950s to the 1980s, plus a nucleus of European art from the early 1980s. A growing collection of twenty-first-century art includes works by established and emerging artists in all media and from around the world. The T. Catesby Jones Collection of French Modernism and the Ludwig and Rosy Fischer Collection of German Expressionism provide outstanding examples of European art in the early twentieth century.

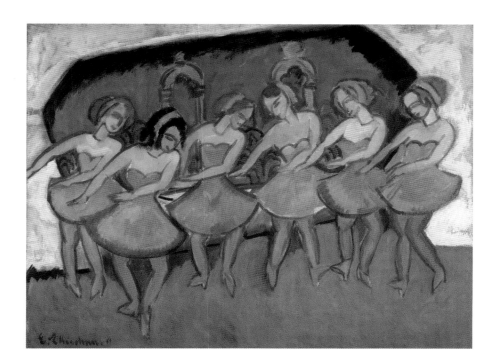

Six Dancers

1911
Ernst Ludwig Kirchner
(German, 1880–1938)
Oil on canvas
37 1/2 × 49 1/4 in.
Ludwig and Rosy Fischer
Collection, Gift of Anne R.
Fischer Estate, and Adolph D.
and Wilkins C. Williams Fund,
2009.171

Kirchner's vivid colors and sharply outlined forms typify Die Brücke, the German Expressionist movement he helped to found. By painting the six dancers nearly all one color—an intense mauve for both dress and skin— Kirchner rendered the women as if they were dolls. Their stiff unnatural poses further this impression, suggesting the artist was as concerned with the overall rhythm and harmony of the composition as with the figures themselves. His attention to pattern, coupled with his bright palette, reflects his interest in the art of Henri Matisse and the Fauves, while the distinctive brushwork and flattened space recall the work of Paul Cézanne.

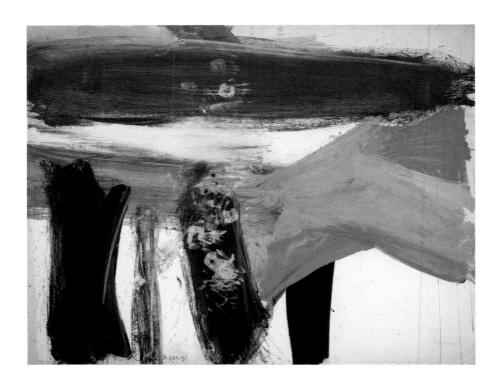

Lisbeth's Painting
1958
Willem de Kooning
(American, 1904–1997)
Oil on canvas
49 3/4 × 63 in.
Gift of Sidney and Frances
Lewis, 85.379

De Kooning's bold, energetic brushstrokes are characteristic of the Abstract Expressionists, who took as their subject the artist's inner life as captured by spontaneous gestures.

The artist (who was born in the Netherlands) recalled returning to his studio the morning after completing this painting to find his two-year-old daughter had pressed her paint-covered hands onto the canvas. De Kooning left Lisbeth's handprints and titled the painting in her honor. Like the Surrealists, who explored the unconscious using chance and randomness, de Kooning and his contemporaries embraced the accidental as an important source of creative expression.

Triple Elvis
1963
Andy Warhol
(American, 1928–1987)
Silkscreen ink, silver paint, spray
paint on linen
81 × 71 in.
Gift of Sydney and Frances
Lewis, 85.453

Warhol based this macho, singer-turned-gunslinger portrait of Elvis Presley on a publicity photograph for the 1960 Western *Flaming Star*. This public persona, as carefully packaged as Campbell's Soup, was ideally suited to the artist's aims and to his focus on surface appearance rather than psychological interpretation. Warhol's repetition of identical images and his silk-screen technique often allude to the pervasiveness of consumer culture. The overlapping multiple figures also suggest individual film frames and cinematic motion, while the work's metallic background evokes Hollywood's silver screen.

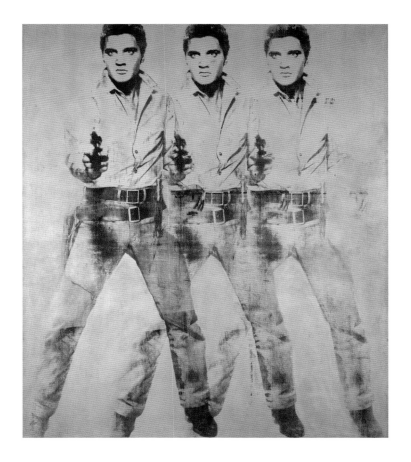

Between the Clock and the Bed

1983

Jasper Johns

(American, born 1930)

Encaustic on canvas

72 × 126 ¼ in.

Gift of Sydney and Frances Lewis and Sydney and Frances Lewis Foundation, 85.411

Beginning in 1972, hatch marks became Johns's principal subject for nearly a decade. In this painting, what at first seem to be random marks are, in fact, a carefully structured system of patterns. The left- and right-hand sections of the three-part painting mirror each other exactly.

Johns's works are often densely layered visual puzzles that explore the paradoxes inherent in the twin poles of painting: abstraction and representation. The title came from a self-portrait by Norwegian artist Edvard Munch (1863–1944) after Johns noticed the resemblance between his own hatch-mark pattern and the pattern of the bedspread in Munch's painting.

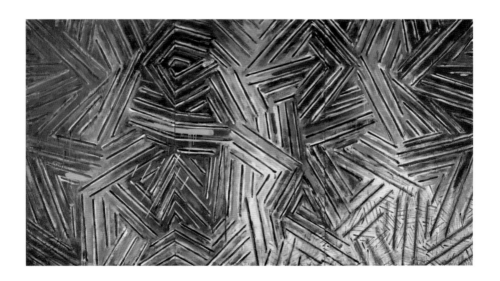

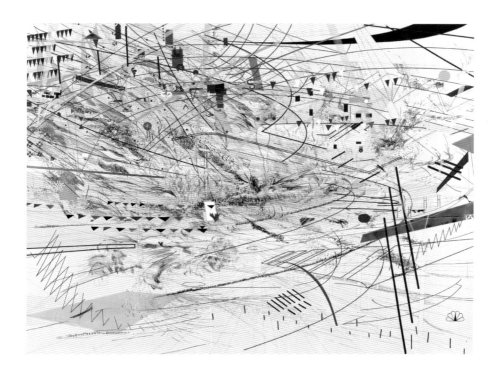

Stadia III

2004

Julie Mehretu

(American, born 1970)

Ink and acrylic on canvas

107 × 140 in.

National Endowment for the Arts Fund for American Art and partial gift of Jeanne Greenberg Rohatyn, 2006.1

Mehretu's monumental paintings address contemporary themes of power, colonialism, and globalism with dramatic flair. This Ethiopian-born artist adapts imagery from architecture, city planning, mapping, and the media. At the same time, her bold use of color, line, and gesture makes her works feel like personal expressions.

Stadia III belongs to a series dealing with the theme of mass spectacle. Conceived in the wake of the Iraq war in 2003, the series reflects Mehretu's fascination with television coverage that transformed the conflict into a kind of video game and juxtaposes that observation with the spectrum of nationalistic responses she witnessed during her travels to other countries.

Cut Ground Red Blue

2009

Sean Scully

(American, born 1945)

Oil on linen

110 x 161 1/4 in.

Gift of Pamela K. and William A. Royall, Jr. in celebration of VMFA's 75th anniversary, 2011.554.a-c

This painting builds on Scully's interest in architecture and demonstrates his desire to join the immateriality of light with the physicality of pigment on canvas. A native of Ireland, this artist was first inspired to paint geometric units of color during a 1972 trip to Morocco, where the colorful stripes and patterned bands of carpets and tents left a strong impression. After visiting Mexico in the early 1980s, he transformed his stripes into bricks of color. Over time, his stroke has softened to reveal underlayers of paint that infuse his minimalist, abstract images with a humanistic touch capable of expressing a wide range of emotions and ideas.

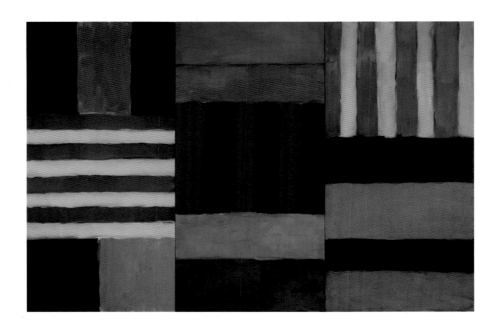

American

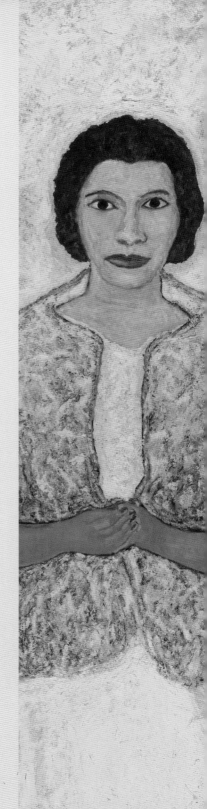

Housed in the James W. and Frances G. McGlothlin galleries, VMFA's American art collection represents four centuries of cultural exchange and development. Objects dating from the late seventeenth to the mid-twentieth century include painting, sculpture, decorative arts, works on paper, and photography. The collection is particularly strong in still-life and landscape paintings from the mid to late nineteenth century, figure painting from the late nineteenth to early twentieth century, objects from the late nineteenth-century Aesthetic movement, original and period picture frames, and works by women and artists of color. The recent installation of seventy-three works from the McGlothlins strengthens the collection with paintings representing American art from the Hudson River School to Modernism.

**Portrait of Prince William
and His Elder Sister, Princess
Sophia**
1779
Benjamin West
(British American, 1738–1820)
Oil on canvas
60 × 84 in.
J. Harwood and Louise B.
Cochrane Fund for American
· Art, 2015.216

Though known as the "father of American painting," the
Pennsylvania-born West also served as president of the
Royal Academy in England, where he spent most of his
career. This portrait of King George III's niece and nephew
was a gift for their father, HRH Prince William Henry. The
painting celebrates the generosity of the king, who, upon
learning of his brother's ill health, petitioned Parlia-
ment for the children's financial support in the event of
their father's death. The small purse William holds and
Sophia's gesture toward the lion, the king's signifier,
symbolize the children's debt to the monarch. The visual
presentation of the patriarchal narrative did dual service
as Revolutionary War propaganda, proclaiming the king's
just authority and due allegiance at home *and* abroad.

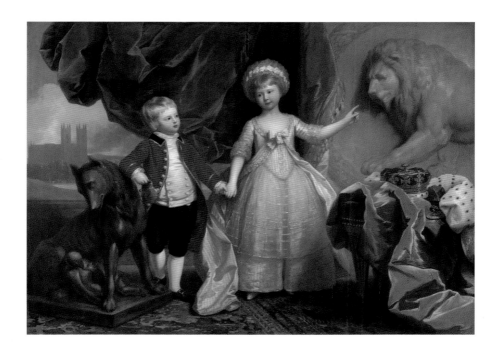

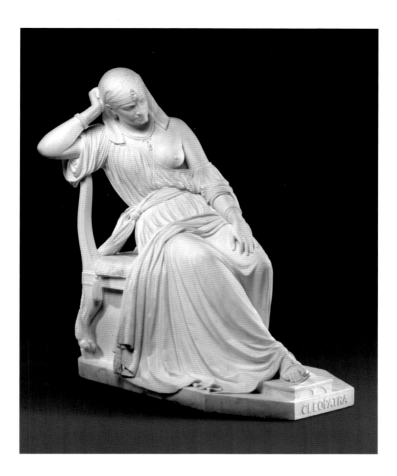

Cleopatra

Modeled 1858, carved 1865
William Wetmore Story
(American, 1819–1895)
Marble
54 × 45 × 27 in.
J. Harwood and Louise B.
Cochrane Fund for American
Art, 2005.73

Story, an expatriate sculptor living in Italy, produced this monumental image of the brooding Egyptian queen. Seated on a throne, Cleopatra seems to be contemplating her past and future deeds.

Created in the mid-nineteenth century, *Cleopatra* represents the high point of fashionable taste for neo-classical sculpture in the United States. American writer Nathaniel Hawthorne, while on a visit to Rome, saw the clay model for *Cleopatra* in Story's studio and immortalized it in his 1860 novel *The Marble Faun*. Story went on to produce several full-scale idealized figures—many of them powerful women from history and mythology—but *Cleopatra* remained his most acclaimed work.

Worsham Rockefeller Bedroom

1881–82, revised ca. 1937
Decoration attributed to George A. Schastey and Company (American, active 1873–97) or Pottier and Stymus Manufacturing Company (American, active 1859–1919)
Furnishings attributed to George A. Schastey and Company and Sypher and Company (American, active 1869–1908)
Ebonized and inlaid mahogany, textiles, metal, glass, ceramic
Approximately 25 × 28 × 12 ½ ft.
Gift of the Museum of the City of New York, 2008.213

This striking bedroom was originally located in a mid-1860s brownstone on West Fifty-Fourth Street in New York City. Richmond native Arabella Worsham purchased the mansion in 1877 and shortly thereafter commissioned a major New York architect and decorating firm to remodel its interiors. A consummate example of the Anglo-American Aesthetic movement, the room expresses what one contemporary reviewer described as an effort to "persuade people to . . . pursue the paths of true art and taste in furnishing their house."

Worsham sold the house to businessman John D. Rockefeller Sr. in 1884. Following his death in 1937, the Rockefeller family donated the bedroom and dressing room to the Museum of the City of New York, which generously transferred the bedroom to VMFA in 2008.

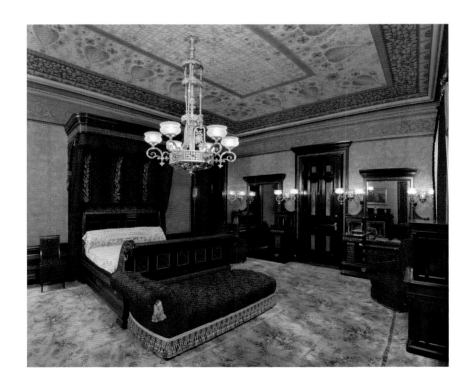

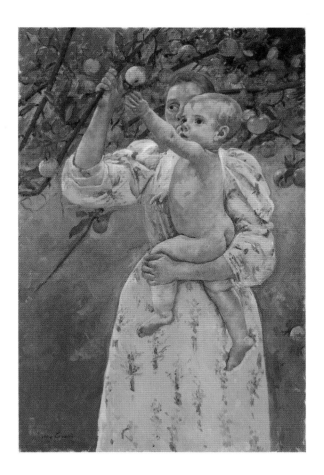

Child Picking a Fruit
1893
Mary Cassatt
(American, 1844–1926)
Oil on canvas
39 1/2 x 25 3/4 in.
Gift of Ivor and Anne Massey,
75.18

This painting merges the subject that made Cassatt famous—a young woman (possibly a mother) and child—with her more ambitious examination of "modern woman," a topical theme at the turn of the twentieth century as the women's suffrage movement gained momentum. The image derives from the artist's now-lost *Modern Woman* mural commission, produced for the 1893 World's Columbian Exposition in Chicago. Cassatt presented her allegorical subject in a three-panel lunette. The large central panel, *Young Women Plucking the Fruits of Knowledge*, featured female figures of different ages clad in contemporary dress and communally harvesting fruit from an orchard.

The Rialto

1909
John Singer Sargent
(American, 1856–1925)
Oil on canvas
21 1/2 × 26 in.
Gift of James W. and Frances G.
McGlothlin, 2014.415

Despite his international fame as society's preeminent portrait artist, Sargent actually preferred depicting scenes of contemporary leisure in rich architectural vistas. In this celebrated painting, the artist employed his characteristically fluid brush to render three fashionably dressed women in a gondola under Venice's renowned Rialto Bridge. The same technical skill is apparent in his attenuated strokes of umber and gold that enliven the water with glistening ripples. The ethereal quality of the figures and setting is contrasted, in part, by the foreground figure of a local boy painted with a tighter, more naturalistic hand.

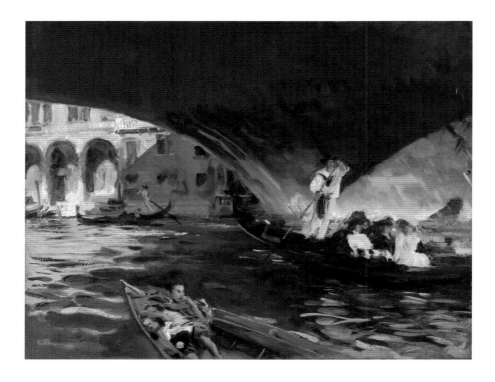

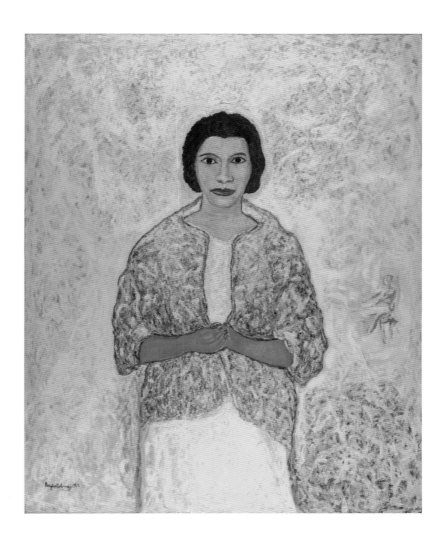

Marian Anderson
1965
Beauford Delaney
(American, 1901–1979)
Oil on canvas
63 × 51 ¹/₂ in.
J. Harwood and Louise B.
Cochrane Fund for American
Art, 2012.277

Delaney painted this iconic portrait of the acclaimed contralto Marian Anderson, whose operatic talent and integrity inspired a generation. In this "memory" portrait—produced in Paris but with an awareness of the civil rights struggles underway in the United States—Delaney expressed his ongoing admiration for Anderson's sensitive brilliance as a performer and person. The visual harmony of the work epitomizes his exploration of painterly abstractions, with the color yellow symbolizing perfection and transcendence.

Teapot and Stand

Ca. 1790–1800
Paul Revere II
(American, 1735–1818)
Boston, Massachusetts
Silver
Teapot: 6 1/4 × 11 3/4 × 3 5/8
Stand: 1 × 7 3/8 × 5 1/4 in.
Gift of Daniel D. Talley III,
Lilburn T. Talley, and Edmund
M. Talley in memory of their
mother, Anne Myers Talley, and
Arthur and Margaret Glasgow
Endowment, 91.392a-b

Revere's elegant teapot and stand mark the new taste for neoclassical designs that came to characterize American craft production in the post–Revolutionary War period. The teapot also reflects changing technologies. Rather than hammering it's hollow form from a silver ingot, Revere used a rolled sheet of silver to shape his fluted vessel. The additional bright-cut decoration satisfied fashionable demand for refined ornamentation. Moses Michael Hays commissioned these pieces in 1796 on the occasion of his daughter Judith's marriage to Samuel Myers, son of Revere's fellow silversmith, Myer Myers. The teapot and stand may have been part of a larger commission for the Hays family, which included a set of coffee spoons also in the VMFA collection.

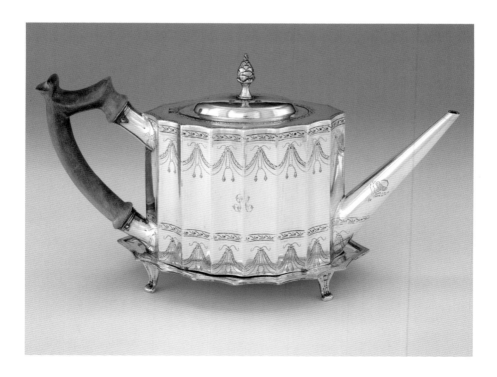

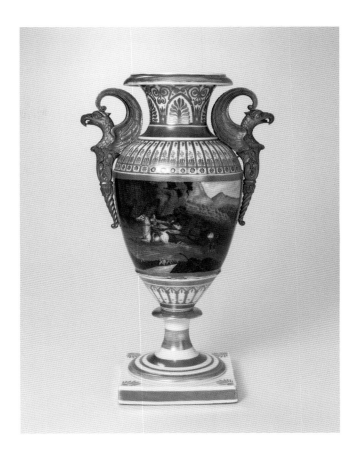

Urn

Ca. 1833–38
Tucker and Hemphill Factory
or Joseph Hemphill Factory/
American Porcelain Company
(American, active 1826–38)
Philadelphia, Pennsylvania
Glazed porcelain, painted with
enamel and gilded;
brass mounts
22 × 12 1/8 × 8 1/2 in.
J. Harwood and Louise B.
Cochrane Fund for American
Art, 2007.19a-c

This monumental urn signals the contemporary influence of French Empire tastes established at the Sèvres porcelain factory during the Napoleonic era. It also reflects an American firm's technical aspirations to compete with European manufactories. The success of the company was recognized in 1833 when Joseph Hemphill's wares were awarded and acclaimed as "in every respect equal to French china."

In addition to the European influence on its design, the urn's boldly rendered, gilt-rimmed pictures hint at the emerging taste for Gothic narratives of captivity and shipwreck. The images are based on prints (*The Rescue* and *The Storm*) by Alvan Fisher, an early New England landscapist whose work is also part of the collection.

European

More than ten thousand objects in all media—paintings, sculptures, decorative arts, and works on paper—dating from the early medieval period to the mid-twentieth century make up VMFA's European art collection. An excellent survey collection, it also contains such major holdings as the Mellon collections of British sporting art, French nineteenth-century art, jewelry and objects by Jean Schlumberger, and American equestrian painting; the Gans collection of English silver with more than one hundred objects by noted London craftsmen; an important group of animal bronzes by Antoine-Louis Barye; and the extensive print collections of Frank Raysor.

The Crucifixion with Saints and Donors
Ca. 1384–93
Altichiero Altichieri
(Italian, ca. 1330–1393)
Tempera on wood
Central panel: 12 $^3/_4$ × 8 $^3/_4$ in.;
each wing: 12 $^1/_4$ × 3 $^3/_4$ in.
Arthur and Margaret Glasgow
Endowment, 59.5

This triptych is one of only two known panel paintings by Altichiero, one of the foremost northern Italian artists of the late fourteenth century. In the center, the Virgin Mary and Saint John the Evangelist mourn the crucified Christ. On the side panels, Saint Anthony Abbot wears a monk's cloak and carries a cross, and Saint Jerome in a cardinal's hat holds a miniature church. Below them, Saints Catherine and James accompany the couple who commissioned the painting. Conservation treatment has revealed that the original donors' portraits were deliberately repainted, possibly when the triptych changed ownership. The later paint has been removed, and those portraits are visible once again.

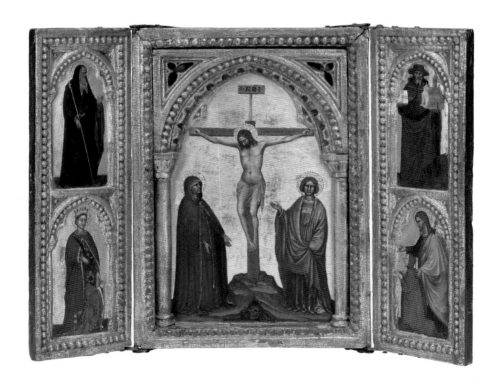

Allegory of Marital Fidelity
1633
Jan Miense Molenaer
(Dutch, 1609/10–1668)
Oil on canvas
39 × 55 ½ in.
Adolph D. and Wilkins C.
Williams Collection, 49.11.19

Once thought to portray a simple musical gathering, this painting is now understood to be a complex allegory about successful marriage. The man pouring wine, for example, acts out the virtue of temperance or moderation. The musicians represent harmony, and their restraint contrasts with the brawling peasants.

Opposite them, the fashionably dressed young man and woman are probably newlyweds. Their dog, a symbol of fidelity, stands guard between them and the monkey and cat, two animals associated with sensuality and cruelty. The painting commemorates the couple's mutual pledge to pursue domestic peace and harmony and to control their baser natures.

Tiger
Ca. 1769–71
George Stubbs
(English, 1724–1806)
Oil on canvas
24 ³/₁₆ × 28 ¹¹/₁₆ in.
Paul Mellon Collection, 99.95

With his unsurpassed knowledge of anatomy, Stubbs became both the foremost painter of animals and a leading English scientist during the Enlightenment of the eighteenth century. Here, he depicts a tiger that was kept in the private zoo of one of his patrons. Although Stubbs and other artists usually portrayed tigers as fierce, this one is shown in a natural state of repose.

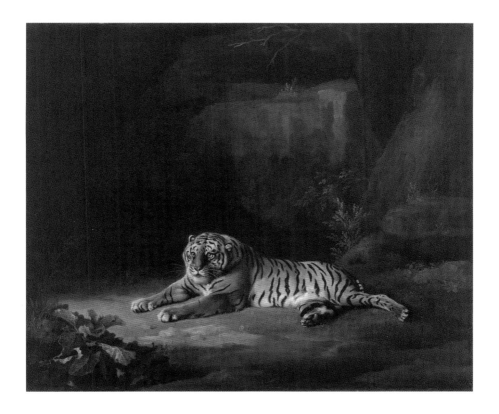

Figure of Hebe

1829–30

Paul Storr

(English, 1771–1844)

Silver

35 1/2 × 10 × 12 1/2 in.

Jerome and Rita Gans Collection

of English Silver, 97.59a-b

Hebe, goddess of youth and daughter of Zeus and Hera, is shown here as a cup-bearer to the gods. The Italian sculptor Antonio Canova executed four monumental versions of the figure of Hebe in marble in the early nineteenth century. Storr created a unique and ambitious replica in silver that emphasizes the sleek, elegant classicism of Canova's original statue.

The Melton Hunt Going to Draw the Ram's Head Cover
1839
Sir Francis Grant
(Scottish, 1803–1878)
Oil on canvas
41 × 65 in.
Paul Mellon Collection, 85.494

Grant was one of only two sporting artists who were elected president of the Royal Academy in London; the other was Sir Alfred Munnings in the twentieth century. This painting, with its complex arrangement of figures, could be considered a portrait of an era as well as a particular group. It shows the fashionable Quorn Hunt of the Melton Mowbray district, an area in central England famous for its fox hunting. The painting was hugely admired when it was exhibited at the Royal Academy in 1839, where it was promptly purchased at a high price by the elder statesman and hero of the Napoleonic Wars, the Duke of Wellington.

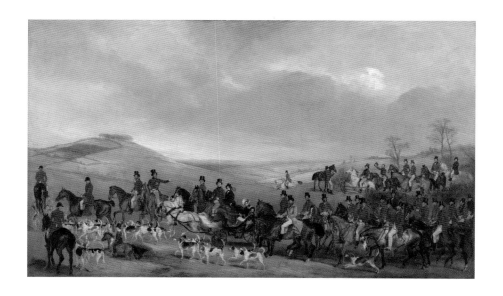

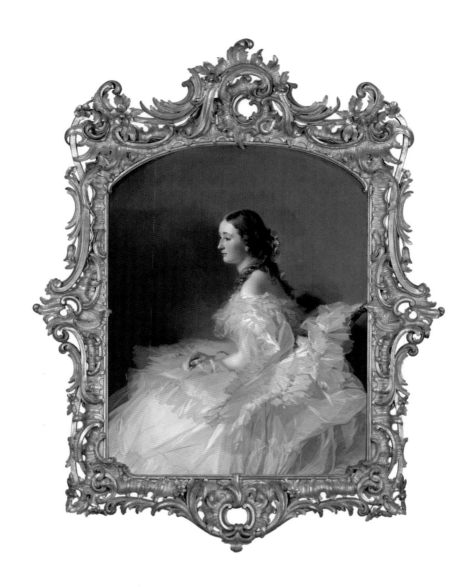

Portrait of Lydia Schabelsky, Baroness Staël von Holstein

Ca. 1857–58
Franz Xaver Winterhalter
(German, 1805–1875)
Oil on canvas
85 1/2 × 66 3/4 × 8 3/8 in.
Adolph D. and Wilkins C. Williams Fund, 2004.69

Winterhalter became a much sought-after artist in the courts of Europe, especially after his successful portraits of both young Queen Victoria of England and Empress Eugénie of France. In this portrait the viewer encounters a ravishing image of a woman of noble pedigree painted at the height of her youthful beauty, with the artist paying much attention to the charming details of her costume, jewelry, and hairstyle.

At the Milliner
Ca. 1882–85
Edgar Degas
(French, 1834–1917)
Oil on canvas
24 × 29 1/2 in.
Collection of Mr. and Mrs. Paul
Mellon, 2001.27

In the 1880s Degas created a compelling series of paintings and pastels centered on the contemporary subject of fashionable women in milliner shops. Here, however, the artist eschews the documentary in order to achieve his stated goal: "At the moment, it is fashionable to paint pictures where you can see what time it is, like in a sundial. A painting requires a little mystery, some vagueness, some fantasy. When you always make your painting perfectly plain you end up by boring people. "

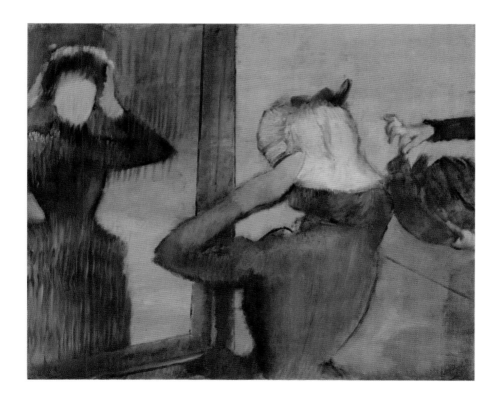

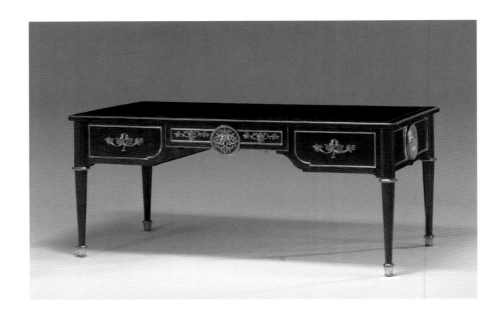

Bureau Plat

Ca. 1780s
Jean-Henri Riesener
(German, 1734–1806; active
in France)
Mottled mahogany, *ormolu*,
leather
30 ¹/₂ × 70 ¹/₂ × 37 ¹/₂ in.
Arthur and Margaret Glasgow
Endowment and by exchange,
gift of Nathalie P. and Alan M.
Voorhees, 2013.169

French master craftsman Jean-Henri Riesener served
as the chief supplier of furniture to King Louis XVI and
Marie-Antoinette from 1774 until the French Revolu-
tion brought an end to his career as a royal *ébéniste*
(cabinetmaker) in 1792. Known for his extensive use of
elaborate marquetry inlays in the 1770s, Riesener came
to rely instead on the decorative qualities of the natural
grain in exotic woods. This *bureau plat*, or writing table,
with its mahogany veneers, is typical of Reisener's simple
but luxurious style. Ornate *ormolu* (gilt-bronze) mounts,
drawer pulls, and other ornaments, such as the roundels
on each end of the desk, complement the natural pat-
terns of the wood.

Decorative Arts
1890 to the Present

Outside Paris, VMFA houses one of the most significant public collections of decorative arts in the French Art Nouveau and Art Deco styles from the years 1895 to 1935. Other highlights of the collection include works by Louis Comfort Tiffany and Arts and Crafts objects by major American and British architects and designers. The museum also has the largest collection of Fabergé objects outside Russia today. These include five imperial Easter eggs that were among the more than four hundred works from the House of Fabergé that Lillian Thomas Pratt bequeathed to VMFA in 1947.

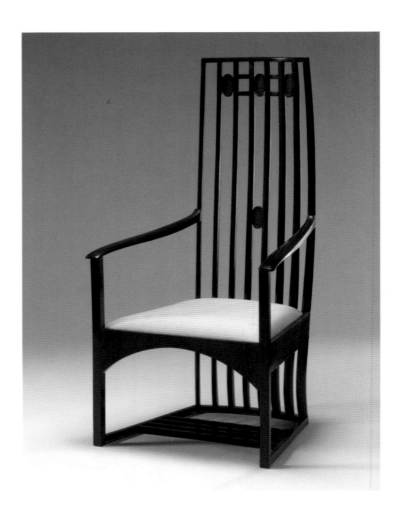

Armchair

1904
Charles Rennie Mackintosh
(Scottish, 1868–1928)
Made by Alex Martin
(Scottish, active 1898–1909)
Glass by McCulloch and
Company (Glasgow, Scotland,
active 1892–1925)
Stained wood, glass,
replacement fabric
47 × 24 ¼ × 25 in.
Gift of Sydney and Frances
Lewis, 85.145

A principal contributor to the Arts and Crafts movement in Scotland, Mackintosh is considered one of the leading architect-designers of the late nineteenth century. Between 1903 and 1919 he created the interior decoration and furnishings for Hous'hill, the residence of Catherine Cranston, who was the originator and owner of a number of tearooms throughout Glasgow. This armchair was made for the drawing room, also known as the music room, one of the distinctive spaces of her house. Its importance lies in the chair's aesthetic appeal rather than in its function or comfort.

Tiffany Punch Bowl

1900
Tiffany Glass and Decorating
Company
(New York, 1892–1900)
Glass, silver, gilding, copper
14 1/4 × 24 in.
Sydney and Frances Lewis Art
Nouveau Fund, 74.16

Once owned by entrepreneur Henry O. Havemeyer of New York City, this Tiffany punch bowl is among the most exceptional objects made by the Tiffany Glass and Decorating Company. Formed of handblown "favrile" glass, the punch bowl has an iridescent surface reminiscent of ancient Roman glass. The gilded-silver mounts are in the form of *C* and *S* scrolls in the fluid Art Nouveau style. The bowl was displayed at the 1900 Paris Exposition Universelle, where Tiffany won a grand prize and received the French Legion of Honor.

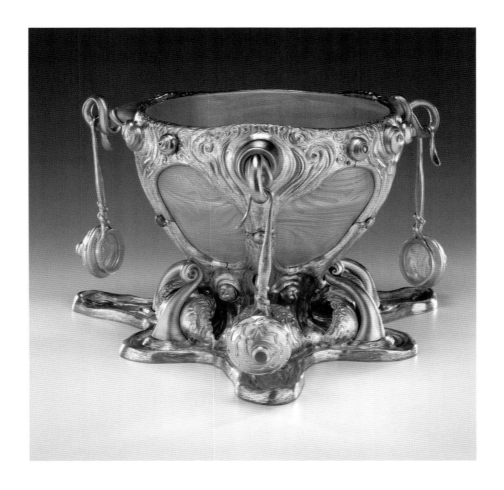

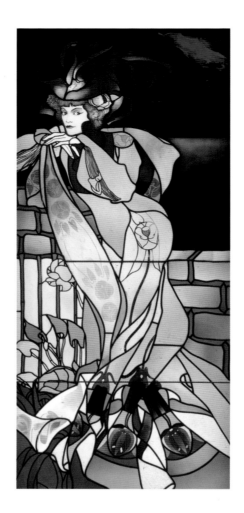

Window

Ca. 1901–2
Georges de Feure
(French, 1868–1943)
Attributed to Hans Müller-
Hickler (German, 1860–1933)
Stained and leaded glass
78 3/4 × 35 13/16 in.
Gift of Sydney and Frances
Lewis, 85.349

At the end of the nineteenth century, de Feure designed
several leaded-glass windows depicting female figures
for Siegfried Bing's pavilion at the 1900 Paris Exposition
Universelle. VMFA's glass window, which was probably
made by Hans Müller-Hickler, was commissioned by
Bing for his Parisian gallery, L' Art Nouveau. Featuring a
female figure surrounded by floral imagery, the window
was most likely shown at the de Feure exhibition held
at Bing's gallery in 1903. The window is among the most
spectacular examples of French Art Nouveau stained
glass in the United States.

Corner Cabinet

Designed 1916, made ca. 1924
Émile-Jacques Ruhlmann
(French, 1879–1933)
Made for Ruhlmann et Laurent
(Paris, active 1919–33) by
Adolphe Chaneux (French,
1887–1965) and Gilbert Pelletier
(French, dates unknown)
Makassar ebony, mahogany,
rosewood, ebony, ivory,
amaranth, brass
50 $^1/_2$ × 33 $^1/_2$ × 23 $^3/_4$ in.
Gift of Sydney and Frances
Lewis, 85.135

Ruhlmann's interior decoration and furnishings represent the height of luxury in the French Art Deco style. During his short career, he set the fashion for wealthy and sophisticated patrons who valued his taste and refinement. This corner cupboard is among Ruhlmann's most elegant pieces. The ivory design on the door represents a vase, inspired by eighteenth-century forms that Ruhlmann often featured in his furniture. Ivory was also used to ornament the cabinet; for example, the door is framed with small ivory dots. Today, only a few such cabinets remain in existence.

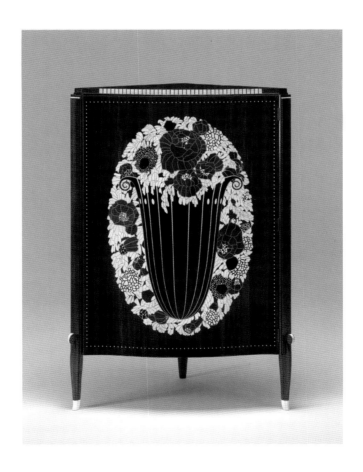

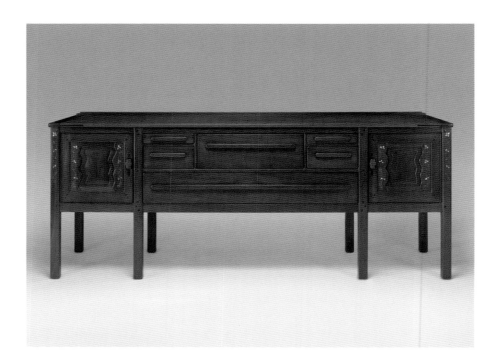

Sideboard
Ca. 1907–9
Charles Sumner Greene
(American, 1868–1957) and
Henry Mather Greene
(American, 1870–1954)
Made by Hall Manufacturing
Company (Pasadena, California,
active 1906–22)
Mahogany, ebony, copper,
pewter, mother-of-pearl
38 1/8 × 95 1/4 × 22 1/4 in.
Sydney and Frances Lewis
Endowment Fund, 93.16

From 1907 to 1909 architects Charles and Henry Greene designed bungalow-style homes for wealthy clients on the West Coast. The house they completed for Robert R. Blacker in Pasadena, California, remains their largest and most splendid commission. Their interest in Japanese art is evident in the overhanging timber construction, lanterns, and refined furniture. This dining room sideboard is one of their masterpieces given its scale, finely carved mahogany, and details of ebony, copper, pewter, and mother-of-pearl.

FABERGÉ EGGS

Imperial Peter the Great Easter Egg

1903
Carl Fabergé
(Russian, 1846–1920)
Workmaster: Mikhail Perkhin
(Russian, 1860–1903)
Gold, platinum, diamonds,
rubies, enamel, silver, gilding,
watercolor, ivory, rock crystal
4 3/4 × 3 1/8 diameter in.
Bequest of Lillian Thomas Pratt,
47.20.33

Fabergé elevated to an art the long-held European tradition of giving jeweled eggs as Easter gifts. Tsar Nicholas II presented this egg, which commemorates the two-hundredth anniversary of the founding of St. Petersburg, to his wife, Tsaritsa Alexandra Feodorovna, in 1903. Portrait miniatures of Peter the Great and Nicholas II appear on opposite sides of the egg. Contrasting royal residences and dates—Peter the Great's humble log home and 1703 versus the tsar's Winter Palace and 1903—are on the other two sides. When the egg opens, a miniature replica of Étienne-Maurice Falconet's statue of Peter the Great on horseback rises out of the shell.

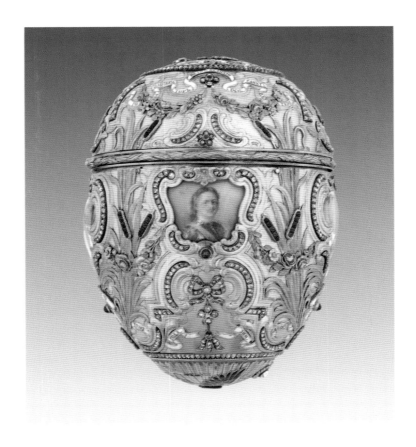

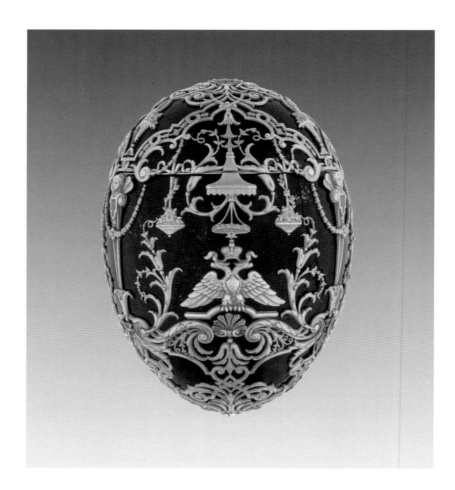

Imperial Tsesarevich Easter Egg

1912
Carl Fabergé
(Russian, 1846–1920)
Workmaster: Henrik Wigström
(Finnish, 1862–1923)
Lapis lazuli, gold, diamonds
Picture frame: platinum, lapis lazuli, diamonds, watercolor, ivory, rock crystal
4 7/8 × 3 9/16 in. diameter
Bequest of Lillian Thomas Pratt,
47.20.34

Tsar Nicholas II gave this egg to Tsaritsa Alexandra Feodorovna in 1912. Its six lapis lazuli sections are enlivened with applied gold decorations of two-headed eagles, winged caryatids, hanging canopies, scrolls, flower baskets, and sprays that conceal the joints. A large solitaire diamond at the base, a thin, flat "table" diamond over the Cyrillic monogram AF (for Alexandra Feodorovna), and the year 1912 complete the ornamentation.

Silver-Mounted Gueridon

1908–17
Carl Fabergé
(Russian, 1846–1920)
Workmaster: Hjalmar Armfelt
(Finnish, 1873–1959)
Palisander wood, nephrite, silver
33 ¹/₂ × 25 ¹/₂ in.
Gift of Forrest E. Mars Jr., John F. Mars, and Jacqueline B. Mars in honor of their mother and father, Audrey M. Mars and Forrest E. Mars Sr., 99.49

Fabergé furniture is extremely rare; only seven pieces have appeared at auction in recent years. This table's form and decoration adhere to the late eighteenth-century European neoclassical style. A silver rim of pierced anthemions above a frieze of silver and nephrite lozenges with neoclassical mounts frames the circular nephrite top. Hjalmar Armfelt, the table's designer, was recognized for creating high-quality gold and silver objects and miniature frames as well as small wooden objects with silver mounts. It is possible that the Fabergé firm hired cabinetmakers in St. Petersburg to produce the wooden structures, which were then ornamented with Fabergé silver mounts and stonework.

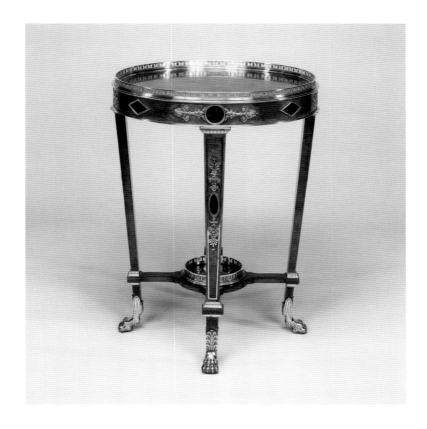

African

The wide-ranging collection of African art at VMFA provides a comprehensive view of the arts and cultural history of that continent from the first millennium BC to the present day. It features figures, masks, textiles, regalia, and ritual objects from more than one hundred cultures, and the representation of contemporary works of art continues to grow. The Dominion African Galleries are organized by cultures, with related works often grouped by theme. Links are drawn to the art of Egypt and Nubia, and a strong section of Ethiopian art enhances these ties historically.

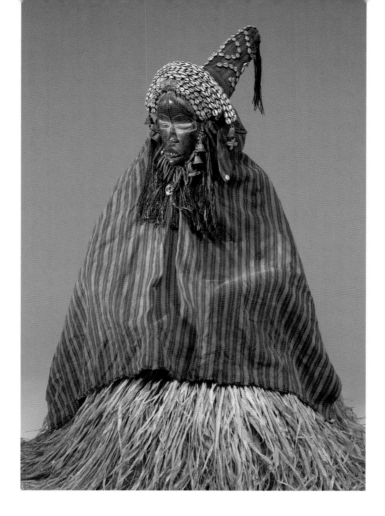

Ga Wree-Wre Mask
19th–20th century
Dan culture
(Liberia, Côte d'Ivoire)
Wood, metal, fiber, cowrie
shells, glass beads, brass, bone,
hand-woven cloth (the raffia
skirt is not original)
47 × 16 × 22 in.
Adolph D. and Wilkins C.
Williams Fund, 92.242

When all the elements of an African mask remain intact,
the visual impact astonishes and commands atten-
tion. Too often masks have been reduced down to the
sculpted face covering by removing the accoutrements
that characterize the spirit represented. Ga Wree-Wre, a
forest spirit summoned into a village to settle an issue,
walks and sits but does not dance. The mask issues its
judgment in a language that requires an interpreter to
translate for the assembled public. Elements of the Ga
Wree-Wre mask contrast the wilderness home (raffia),
where the spirit dwells, with the village, denoted by the
human features, headdress, and woven cape.

King's Beaded Robe
Early 20th century
Yoruba culture (Nigeria,
Republic of Benin)
Glass beads, string, velvet,
wool, damask
47 3/4 × 75 in.
Kathleen Boone Samuels
Memorial Fund and Arthur and
Margaret Glasgow Endowment,
96.36

The glorious colors of a Yoruba king's robe "feed the eyes" with colors that identify *orishas* (deities) important to the wearer. Radiant beads intensify these associations and telegraph wealth and power. Such beads are reserved for the *alaashe*—those who bring *ashe* (vital force) to bear— including rulers, priests, diviners, and maskers.

This robe's many colors make visible reference to the invisible forces of multiple *orishas*. White and sparkling clear beads ripple across the surface, illustrating Olokun's association with the sea. Ogun's kingly power is declared with black and green beads in the collar surrounding the face of Oduduwa, the first Yoruba king. His symbolic image is emblazoned on the back of the robe.

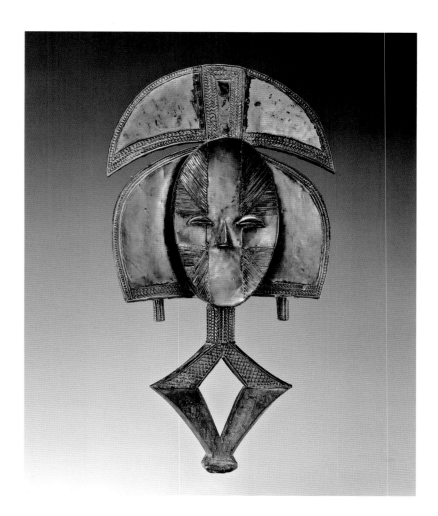

Reliquary Guardian Figure
19th–20th century
Kota culture (Gabon, Republic
of Congo)
Wood, brass, copper
28 1/4 × 15 1/4 × 3 in.
Robert and Nancy Nooter
Collection, Adolph D. and
Wilkins C. Williams Fund,
2003.14

Originally lashed to a container holding ancestral relics,
this guardian sculpture abounds with symbolism. Sheets
of copper form a cross that divides the face into quad-
rants, while the "legs" form a diamond. These geometries
refer to dawn, noon, sunset, and midnight, the four phases
of the sun that are visual metaphors for the stages of life.
The crescent moon above the head indicates nighttime,
when it is day in the realm of the ancestors. Copper and
brass honor the deceased. Like reflections on water, their
glossy metal surfaces evoke the watery boundary thought
to exist between the living and the dead.

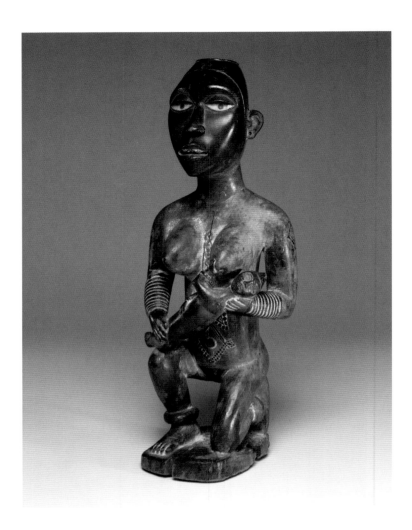

Mother and Child
Late 19th–early 20th century
Vili people, Kongo culture
(Republic of the Congo, Gabon)
Wood, glass, paint, kaolin,
camwood powder
19 ¹/₂ × 7 × 6 in.
Adolph D. and Wilkins C.
Williams Fund, 87.84

In this poignant sculpture, a mother's concern for her sick child registers in her solemn expression and her reverent, kneeling posture. The child's gestures indicate that his survival is at risk. He clutches his stomach and turns away from his mother's breast. The statue is an *nkisi* (pronounced in-kee-see), or power figure, intended for use in divination rituals that search for the cause of illness in order to prescribe a cure. Cavities in the mother's back and head, now empty, would have been filled with ritual medicines to endow the statue with supernatural power.

Processional Cross

17th–18th century
Ethiopia
Silver
16 × 10 ⁷/₈ × 1 ¹/₂ in.
Gift of Robert and Nancy
Nooter, 2012.288

Images on both sides of this elegant cross deepen its message and enhance the shimmering surfaces. On the side shown, Mary, crowned Queen of Heaven, holds the Christ Child and extends two fingers in blessing. Seraphim flank the holy pair while the archangels Gabriel and Michael stand guard on the side arms of the cross. A figure on the left arm may represent the donor. The cross is inscribed in Ge'ez, the ancient language of the Ethiopian Church: "This is the cross of Wälättä Dengel, which she donated to Däbrä Mika'el [Monastery of St. Michael], of Dämba, so that it might be a guide [for her] to the kingdom of heaven." On the reverse, the cross is etched with images of the Crucifixion and Resurrection.

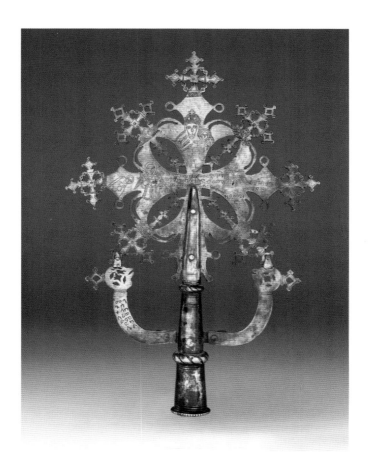

Pre-Columbian and Native American

The history of ancient American cultures lasted from approximately 1500 BC until the arrival of the Spanish in the early sixteenth century. The Pre-Columbian collection at VMFA includes a range of Meso and South American ceramic vessels, precious metalwork, and textiles representing the religious customs, political structure, and daily lives of ancient indigenous peoples. Largely due to the generosity of Robert and Nancy Nooter, the Native American collection features North American Indian ceramics, baskets, and rugs from the cultures of the Pacific Northwest coast, Plains, and Southwest United States.

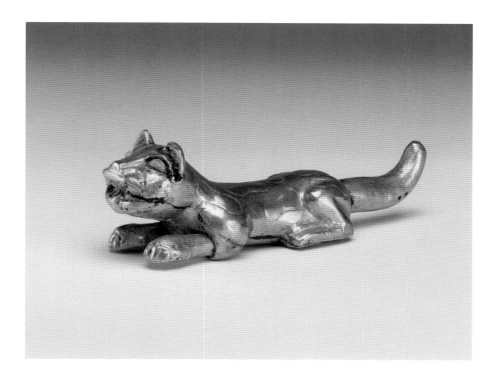

Jaguar
400–100 BC
Moche style (Peru)
Gold with green stones
1 1/4 × 4 1/4 in.
Arthur and Margaret Glasgow
Endowment, 59.28.9

Of all the creatures worshiped by Pre-Columb an peoples, predatory felines such as the jaguar were the most respected. Possessing exceptional hunting ski ls and no natural enemies, these animals moved between different realms of nature since they could swim rivers and climb trees as well as live on land. Their adaptability endowed them with symbolic and supernatural importance. At least seven identical copies of this jaguar are known. Pairs of holes in the tail and lower body suggest it was originally sewn to a headband, shirt, or belt. The hollow figure also holds a pebble, causing the ornament to rattle when worn.

Tabard

400–700
Nazca (Peru)
Feathers on cotton
46 × 30 ½ in.
Arthur and Margaret Glasgow
Endowment, 60.44.3

Considered a precious luxury item by ancient Americans, this masterpiece of Andean featherwork is one of only three Nazca tabards known to exist. The term *tabard* applies to this tunic-like garment because it was designed to hang straight down from the wearer's shoulders. Since it is not tied or sewn at the sides, the feathers hang freely and catch the light, creating stunning visual effects.

The brightly colored feathers come from indigenous birds. While the exact species of each feather is yet to be determined, the blue and yellow feathers are probably from the macaw and the coral-colored feathers may be from the flamingo.

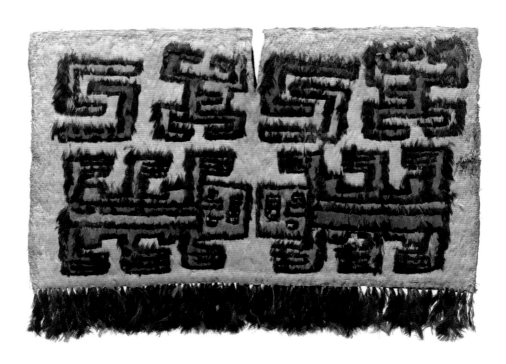

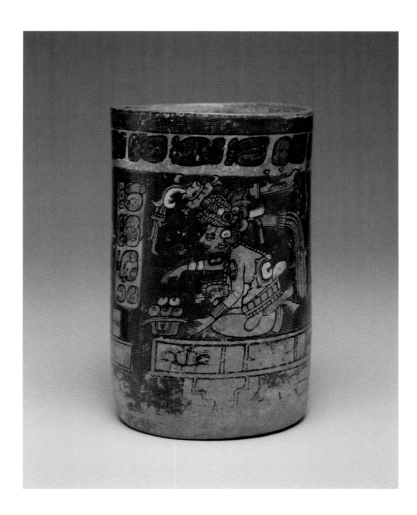

Funerary Vessel

700–800
Maya (Mexico or Guatemala)
Terracotta with polychrome
pigments
6 1/4 × 7 5/8 in. diameter
Adolph D. and Wilkins C.
Williams Fund, 77.98

This cylindrical drinking vase is a superb example of low-fired Maya ceramics. The artist used water-based clay slip as a way to paint over the lighter clay base to create the rich red hues of the hieroglyphs and the background of the narrative scene. Although the exact purpose of this vessel is unknown, it was almost certainly placed in the grave of an elite member of Maya society, where it would have been filled with sustenance for the afterlife. The imagery illustrates three important members of the Maya pantheon: a scribe; Itzamna, the supreme Maya god; and the Moon Goddess.

Cradleboard

Ca. 1880
Ute (Utah)
Hide, seed and Russian trade
beads, wood frame
30 × 10 × 7 in.
Robert and Nancy Nooter
Collection, L.25.2009

Baby carriers and cradles were an esteemed art form among many groups of Plains Indians. Adorned with lavish beadwork or quillwork, they were symbolic of female industry and achievement. Cradles were, in fact, so prestigious that they were sometimes presented as gifts in contexts outside of child bearing, such as the successful conclusion of a peace agreement. These objects provided both physical and spiritual protection to the baby and announced the child's social standing. The rare blue Russian trade beads used on this cradleboard conferred a certain amount of status. Red, white, gold, and blue seed beads were used in a spare yet beautiful design on the cradle's outer edge and at the opening for the baby's head.

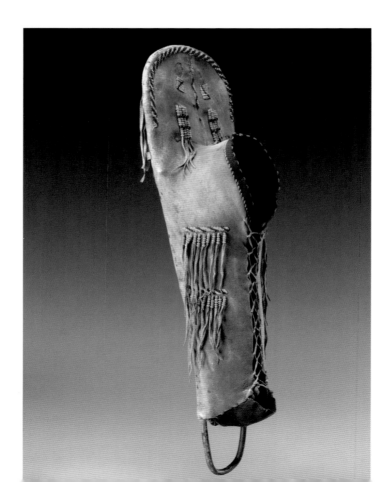

Dream Dance Mask

Late 19th century
Yup'ik (Alaska)
Wood, pigment, feathers
13 × 12 in.
Robert and Nancy Nooter
Collection, Arthur and Margaret
Glasgow Endowment, 2013.238

The Yu'pik people rely on the natural world, and reciprocity between humans and animals is central to this idea. Much of their artwork illustrates and enhances this concept while also enriching their ceremonial life. The Yu'pik engage in a complex cycle of six ceremonies that take place within the *qasgiq* (men's house) during the long winter months. Integral to this cycle is the art of masquerade, which includes both making masks and performing with them. Dances with masks serve many important purposes, such as storytelling or recounting historical or mythical events. Another is to honor the spirits of animals that have given their lives to hunters and to petition their generosity in the future.

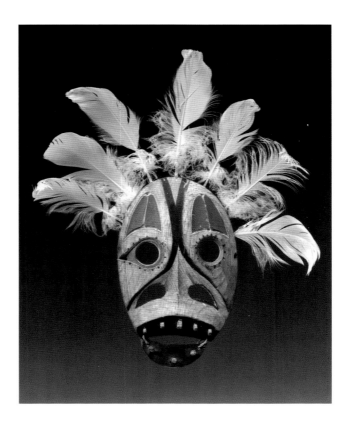

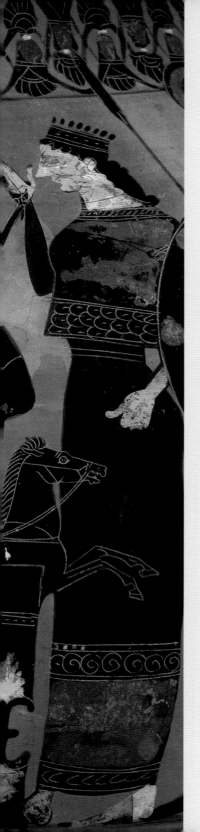

Ancient Mediterranean

The museum's collection of ancient Mediterranean art spans more than 6,000 years of human history, from pre-dynastic Egypt in the fourth millennium BC through the fall of the Byzantine Empire in 1453. Comprised of objects from the cultures of Egypt, the Near East, the Aegean, Greece, Etruria, the Roman Empire, and Byzantium, the collection is particularly strong in Greek pottery from the Bronze Age through the Hellenistic period. Also significant are holdings in Late Period Egyptian art and Byzantine jewelry as well as excellent examples of Roman sculpture.

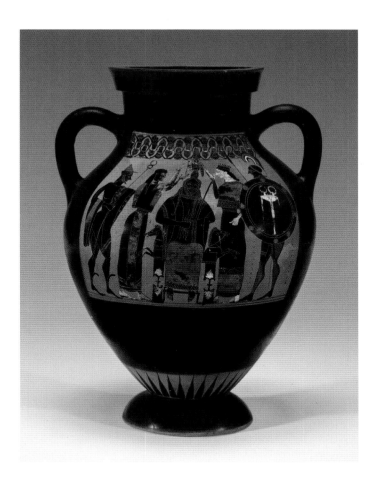

Black-Figure Amphora
Ca. 540 BC
Greek (Attic)
Attributed to a Painter of
Group E
Side A: Birth of Athena
Side B: Herakles and the lion
Terracotta
16 ³/₄ × 11 ¹/₄ in.
Arthur and Margaret Glasgow
Endowment, 60.23

*Athena sprang quickly from the immortal head and stood
shaking her sharp spear before aegis-bearing Zeus.*
Homeric Hymn to Athena, 28

In this scene of Athena's birth, the artist has depicted
both the goddess and Zeus in a frontal pose—a unique
arrangement for this period. The springing horses are the
arms of Zeus's throne. According to the seventh-century
poet Hesiod (active 750–650 BC), Zeus swallowed his
first consort, Metis (wisest of gods and men), because
of a prophecy that she would bear a son who would
overthrow him. Metis was already pregnant with Athena,
who sprang fully grown and armed from Zeus's head.

**Emperor Gaius Julius Caesar
Augustus Germanicus**
Ca. 38
Roman
Marble
80 × 26 ¹/₂ × 19 ¹/₂ in.
Arthur and Margaret Glasgow
Endowment, 71.20

Emperor Gaius is better known as Caligula ("Little Boot")
after the military boots he wore as a child. He reigned
only four years (37–41) before his assassination and was
so reviled that only one other full-length statue of him
survives from antiquity. This statue was discovered in an
imperial shrine near Rome. Here, Caligula wears a toga
and aristocratic footwear, emphasizing the emperor's
role as statesman and *princeps* (first among equals). The
quality of the carving and attention to detail—the toga
even has fold lines—indicate the statue was carved in an
imperial workshop.

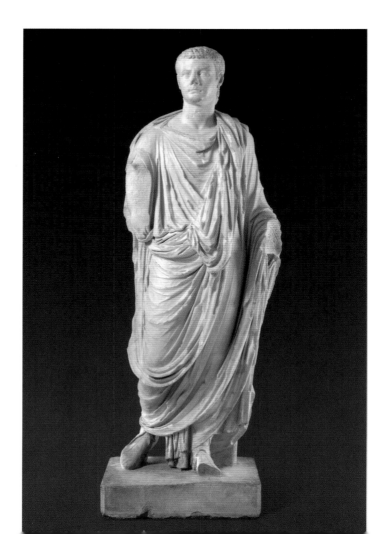

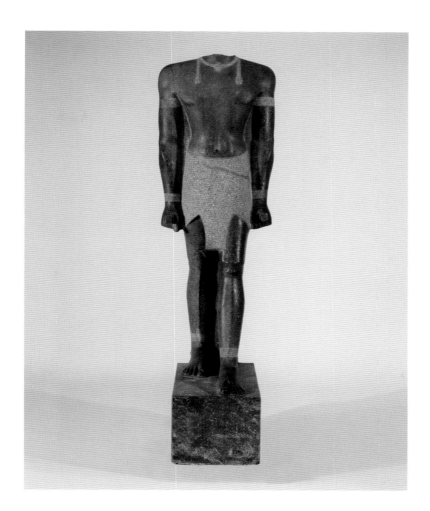

**Statue of Senkamanisken,
King of Kush**
643–623 BC
Kushite (Nubian)
Gray-black granite
70 × 25 × 30 3/4 in.
Adolph D. and Wilkins C.
Williams Fund, 53.30.2

Inscriptions on the back pillar identify this figure as
Senkamanisken, King of Kush, an ancient African empire
in what is now Sudan. The Kushites vied with the Egyp-
tians for control of the Nile Valley and ruled all or part
of Egypt during Dynasty 25 (760–656 BC). The tripartite
shendyt (royal kilt), frontal presentation, and stiff pose
are in keeping with Egyptian depictions of rulers, but the
thicker legs accord with Kushite artistic conventions. In
antiquity, gold or silver would have covered the rough
portions of the stone to create a striking contrast with
the highly polished granite surfaces.

Pair of Openwork Armbands

Late 3rd or early 4th century
Late Roman
Gold, emeralds, sapphires
4 ¹/₂ in. diameter
Adolph D. and Wilkins C.
Williams Fund, 67.2.31.1–2

These armbands are masterworks of *opus interrasile* (openwork) jewelry in which the artist used drills and chisels to produce the design. Especially popular in late antiquity, the technique resulted in jewelry that was far heavier and costlier than more typical pieces made of gold sheets. Each armband consists of geometric and vegetal patterns surrounding four sapphires and four emeralds, and each has two sections joined by a hinge and a clasp. While these armbands were probably found in Syria, similar jewelry has been discovered throughout the Mediterranean region.

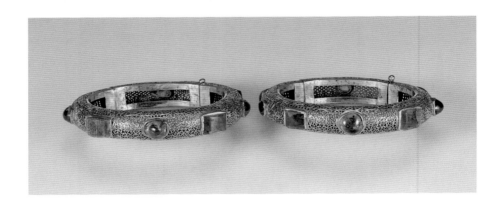

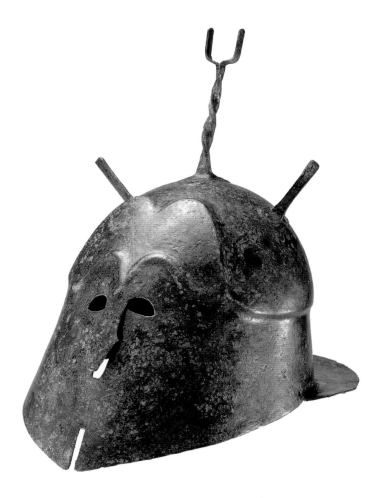

Apulo-Corinthian Helmet
5th century BC
Greek (South Italian)
Bronze
10 1/2 × 8 1/4 × 11 7/8 in.
Arthur and Margaret Glasgow
Endowment, 2004.3

Popular throughout the Greek world, the Corinthian helmet not only provided effective protection for the wearer's face and head, but it was also easily made from a single hammered sheet of bronze. This example, common in the southern Italian region of Apulia, features prongs to attach a horsehair crest or other forms of decoration. Greek military tactics of the classical period relied on formations of massed infantry acting cohesively. The limited range of vision afforded by the helmet would not have hampered a soldier's effectiveness in combat unless the battle line broke.

East Asian

Representing more than 4,500 years of visual history, VMFA's East Asian collection features paintings, prints, sculpture, ceramics, metalwork, lacquers, and other decorative arts from China, Japan, and Korea. Collection themes include the Bronze Age, the spread of Buddhism, the development and trade of ceramics, scholars' implements, samurai culture, the tea ceremony, and incense art. These works, acquired either as generous gifts or museum purchases, reveal influences and interactions within East Asia and beyond.

Fugen on an Elephant
14th century
Japanese, Kamakura period
(1185–1333)
Wood with polychrome,
lacquer, copper, crystal, glass
98 7/8 × 35 13/16 × 56 11/16 in.
Adolph D. and Wilkins C.
Williams Fund, 66.73.2

As described in the *Lotus Sutra*, this sculpture is one
of a pair that portray the Buddhist deities Monju and
Fugen as symbols of wisdom and protectors of Buddhist
law. Made of multiple sections of wood, the imposing
sculptures were wrapped with hemp before layers of
lacquer were applied to protect the wood from cracking
and worm damage. The traces of cut-gold foils reveal the
intricacy involved in making Buddhist sculptures during
the Kamakura period. Conservation of these sculptures
was funded by the Weedon Foundation.

View of Unzen from Amokusa

1937
Kawase Hasui
(Japanese, 1883–1957)
Watercolor; ink and color
on paper
16 1/4 × 10 3/4 in.
René and Carolyn Balcer
Collection, 2012.220

A distant view of Mount Unzen, an active volcano and a national park located on Kyushu Island in Nagasaki prefecture, is depicted in this watercolor. The region is known for its early embrace of Roman Catholicism, which Portuguese and Spanish missionaries introduced to Japan in the sixteenth and seventeenth centuries. Hasui's early training in Western techniques is clearly evident here. The painting serves as a rare example for studying the process in Hasui's printmaking and the relationship between his watercolors and prints.

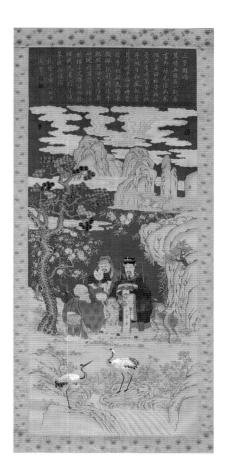

In Praise of the Three Stars
1782–92
Chinese, Qing dynasty,
Qianlong period (1736–95)
Hanging scroll; kesi tapestry
with silk and metallic threads,
embroidery, painted design
86 7/8 × 52 3/8 in.
Gift of Mr. Christopher T.
Chenery, 64.41

Two immortal boys appear on this tapestry (shown here in detail) with the legendary Chinese deities known as the Three Stars. The God of Happiness, or Jupiter, holds one of the boys; the God of Prosperity, the sixth star in the Ursa Major constellation, wears a crown; and the God of Longevity, a symbol of the South Star, offers a peach. With floating clouds and soaring mountains in the background, the picturesque landscape includes peach-filled trees as well as peonies and chrysanthemums in full bloom. The integration of *kesi* (cut-silk) weaving, embroidery, and painting makes this scroll one of the most spectacular tapestries produced in the Suzhou imperial workshops of China during the eighteenth century.

King Sagara

Ca. 1740
Chinese, Qing dynasty,
Qianlong period (1736–95)
Hanging scroll; ink, color, and
gold on silk
5 1/2 × 22 in.
Arthur and Margaret Glasgow
Endowment, 2004.70.1

King Sagara, who governed northern India in the seventh century BC, descends from the clouds with monster-like attendants carrying exotic tributes and treasures from the ocean. The inscription in the lower left corner, "Respectfully commissioned by the imperial Prince Zhuang," suggests this work was most likely commissioned by Yunlu (1695–1767), son of Emperor Kangxi, who inherited the title Prince Zhuang and was appointed by Emperor Qianlong in 1736 as a court official in charge of rituals, music, and publications.

Winter Landscape

November 1957
Lee Sangbeom
(Korean, 1897–1972)
Ink and color on paper
9 1/8 × 15 7/8 in.
Gift of Dr. and Mrs. Herbert A.
Claiborne Jr., 2004.74

Countryside landscapes are characteristic of the style of Lee Sangbeom, who signed this work with his pseudonym Cheongjeon. This painting depicts a man and his loaded donkey walking along a narrow path through the snow-laden landscape. Notable for using traditional ink, white pigment, and economic brushwork, Lee presents an idyllic winter scene in the distinctive style of modern Korean painting. Born in Gongju, Lee taught at Hongik University and Ewha Womans University. He received numerous cultural awards throughout his life.

South Asian

In the late 1960s, Paul Mellon provided funds for the purchase of a large portion of the Nasli and Alice Heeramaneck Collection. Since that time, the museum's South Asian collection has greatly expanded through acquisitions and gifts. Today, it ranks as one of North America's premier collections of Indian and Himalayan art.

Shiva as King of Dancers
(Nataraja)
Mid-12th century
Indian, Tamil Nadu, Thanjavur
(Tanjore) District
Copper alloy
38 5/8 × 28 × 12 in.
Adolph D. and Wilkins C.
Williams Fund, 69.46

Dynamically posed within a ring of flames, long locks wildly flying, Shiva performs the cosmic dance that creates, sustains, and destroys the universe. The drum in the upper right hand represents sound, the prime element that signals creation and the beginning of time. The flickering flame originally held in the upper left hand symbolizes the great fire that will engulf the universe at the end of time. Wearing two different earrings to signify that they are both male and female, Shiva tramples the demon of ignorant forgetfulness. The devotee who comprehends the full meaning of Shiva's dance might attain release from time's unending cycles.

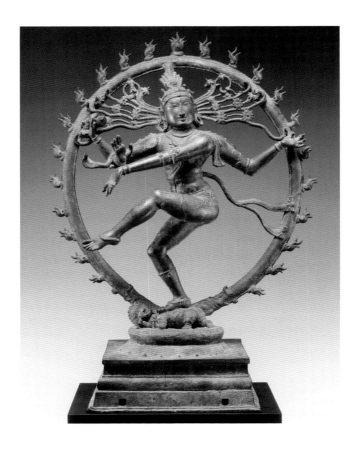

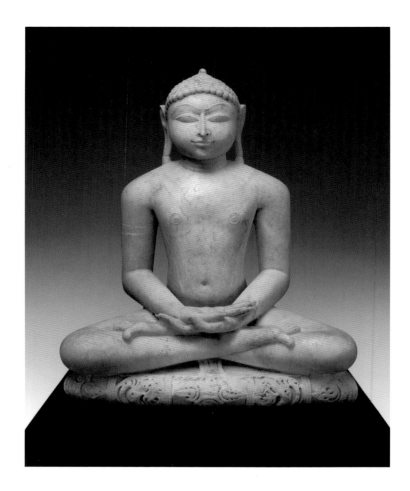

**Jina, Probably
Shreyamsanatha**
1160
Indian, Rajasthan, probably
vicinity of Mount Abu
White marble with slight traces
of pigment
23 5/8 × 19 1/8 × 10 in.
Adolph D. and Wilkins C.
Williams Fund, 2000.98

Serenely seated in meditation, this Jina, or Tirthankara, is one of the twenty-four great teachers and exemplars of the Jain faith. An inscription on his elegantly decorated cushion gives the sculpture's date and the names of those responsible for its commission and installation. While the Jain's body is abstracted into almost pure geometrical shapes, it retains an inner vitality. Lotus medallions on his large hands and feet indicate his extraordinary status. A strip of cloth emerging near his feet shows he is not entirely nude but meagerly clad in the manner of an ascetic. Traces of color indicate the sculpture was once painted.

Talismanic Shirt

Ca. 1400–1550
Indian, North India or Deccan
Ink and opaque watercolor on
cotton
25 × 38 ¼ in.
Robert A. and Ruth W. Fisher
Fund, 2000.9

This small cotton tunic is inscribed with the entire text of the Qur'an, the holy book of Islam. Such shirts were probably worn to protect wearers from the perils of illness, enemies, and evil. The Qur'anic verses are penned in fine black and red ink within square cells on the main body of the tunic and in the curved lappets below. Larger roundels on the shoulders, breast medallions, an elongated cartouche on the back, and a wide band surrounding the shirt's collar, sleeves, sides, and front opening all contain textual references to God (Allah).

Vajrabhairava
15th century or later
Sino-Tibetan
Polychromed wood
53 $\frac{1}{4}$ × 50 $\frac{3}{4}$ × 30 $\frac{3}{4}$ in.
E. Rhodes and Leona B. Carpenter
Foundation and Arthur and
Margaret Glasgow Endowment,
93.13

Known by his epithet Yamantaka (Slayer of Yama, the
Lord of Death), Vajrabhairava personifies the victory of
spiritual wisdom over death. Ferocious and command-
ing, the buffalo-headed Buddhist deity subjugates gods,
demons, birds, and animals that stand for evil and suffer-
ing. A garland of severed heads, symbolizing the conquest
of the ego, hangs from his neck. The implements in his
thirty-four hands represent different aspects of spiri-
tual knowledge. Many are weapons he uses to destroy
obstacles to enlightenment. This otherwise terrifying
deity is a cosmic emanation of Manjushri, the bodhisattva
of wisdom, whose serene face emerges from the top of
Vajrabhairava's crown.

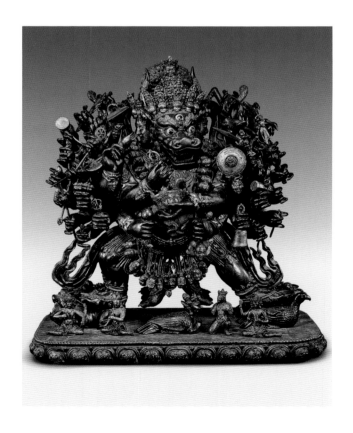

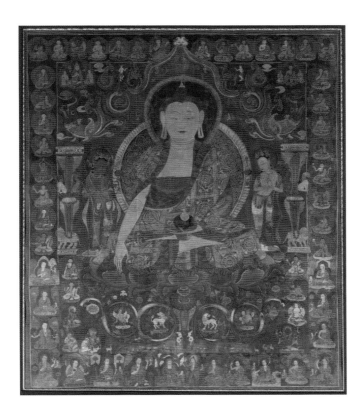

Shakyamuni Buddha with Two Bodhisattvas, Thirty-Five Buddhas of Confession, and Seventeen Arhats

Ca. 1450–1500
Western Tibetan
Opaque watercolor on cloth
40 ¹/₂ × 34 ¹/₄ in.
Nasli and Alice Heeramaneck Collection, Gift of Paul Mellon, 68.8.119

Dominating this Tibetan painting is the powerful yet serene figure of Shakyamuni, the historical Buddha. Flanked by the bodhisattvas Manjushri and Maitreya, he sits on a lotus throne that rises from a pool of water. The back of an elaborate arched throne frames the trio; among the figures above is Tsongkhapa, founder of the Geluk monastic order. Around the upper borders are thirty-four buddhas backed by circular red nimbuses. Along with Shakyamuni, they comprise the Thirty-five Buddhas of Confession, omnipresent powers for good in the universe. Around the lower borders are seventeen arhats, enlightened monks who will teach the Buddha's doctrine until the arrival of his successor.

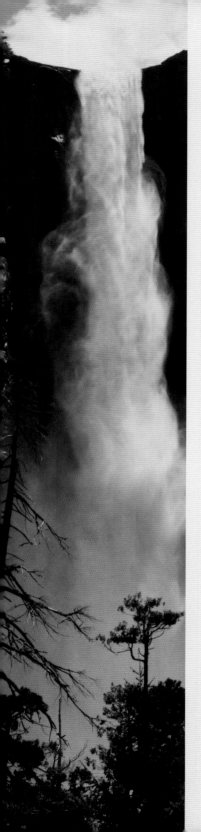

Photography

The Carnegie Corporation's gift of photographs by Frances Benjamin Johnston, including her views of Virginia architecture, led to the founding of VMFA's photography collection. From 1936 to 1956 members of the Camera Club of Richmond also donated photographs, and in 1973 VMFA began to build the collection strategically, with an eye toward key moments in the history of the medium. Private collectors provided works by several noted twentieth-century photographers, including Ansel Adams, Gertrude Käsebier, Clarence John Laughlin, Aaron Siskind, and Garry Winogrand. VMFA seeks to further diversify its collection with acquisitions by photographers from around the world and from Virginia.

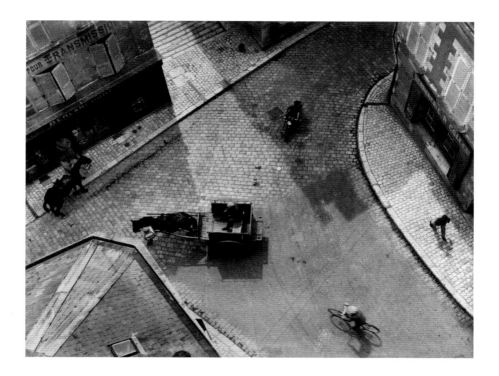

Carrefour Blois
1930
André Kertész
(American, 1894–1985)
Gelatin silver print
10 ¹⁵/₁₆ × 13 ⁷/₈ in.
Adolph D. and Wilkins C.
Williams Fund, 2008.160

Kertész actively photographed while living in his homeland of Hungary, but his career was transformed when he moved to Paris in 1925. There, he entered the currents of modernism, including Cubism and Dadaism, which enlivened the city's artistic circles at that time. A versatile photographer, Kertész was well known for his street scenes and for compositions that reveal distinctive points of view.

Bridalveil Fall
Ca. 1952
Ansel Adams
(American, 1902–1984)
Gelatin silver print
11 1/8 × 7 3/4 in.
Gift of Dr. and Mrs. Bernard J.
Sararoff, 86.206.2/4

During his sixty-year career, Adams was consistently inspired by the mountains, forests, and rivers of California's Yosemite Valley and High Sierra. He made thousands of negatives and printed hundreds of images of this varied landscape.

Adams considered Bridalveil Fall "the most beautiful of all the Yosemite waterfalls." Its sunstruck water and shadowy cliffs offered the effects of light that interested Adams, as well as the monumentality he sought. The museum's print appeared in *Portfolio III*, one of seven portfolios that featured what Adams considered to be his best images.

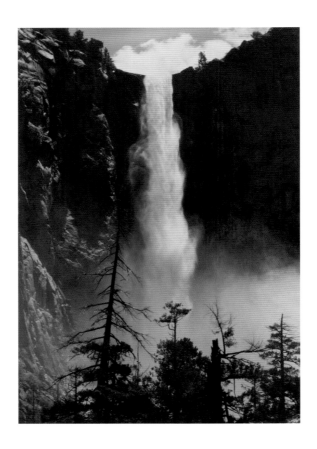

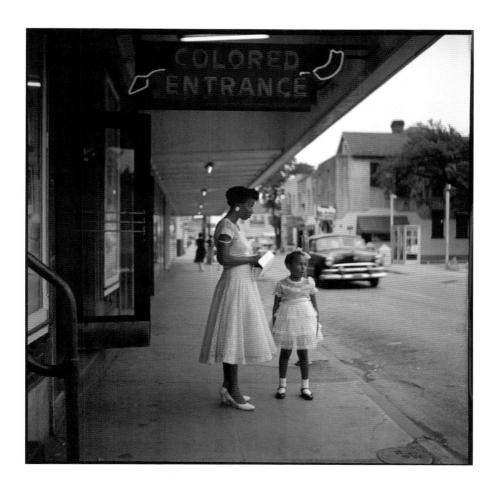

Untitled, Mobile, Alabama, 1956
1956, printed 2012
Gordon Parks
(American, 1912–2006)
Pigment print
14 × 14 ⅛ in.
Funds provided by Linda Sawyer, 2012.281

This photograph powerfully illustrates the challenge of navigating daily life while maintaining dignity under segregation. Sent on assignment for *Life* magazine, Parks documented how segregation affected one family in Mobile, Alabama. Some members of the family lost their jobs for participating in the photo essay and ultimately had to relocate, yet the family never regretted its role in the project. Instead, they considered it an act of resistance in the struggle for civil rights.

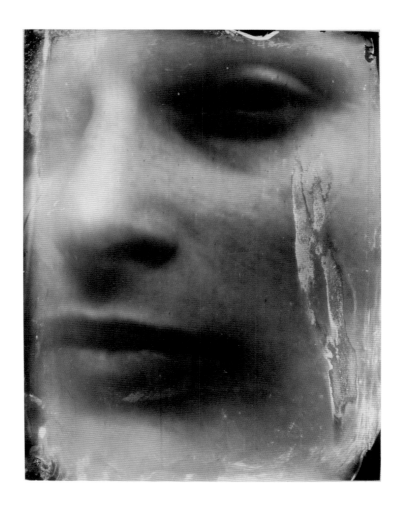

Jessie #34
2004
Sally Mann
(American, born 1951)
Gelatin silver print
50 × 40 in.
Arthur and Margaret Glasgow
Endowment, 2006.13

Mann came to prominence in the early 1990s for candid images of her young children in and around their Virginia home. These idyllic views of everyday life offer intimations of sensuality and mortality that perhaps lay beyond the subjects' grasp. In this later work, scratches, blurs, fissures, and peeling—accidental artifacts of the nineteenth-century collodion wet plate process that Mann employs—emphasize the photograph's physical nature and add another layer of gravity by suggesting the ravages of time.